BASICS

TECHNICAL
DRAWING

\\ BERT BIELEFELD \\ ISABELLA SKIBA \\

BASICS

TECHNICAL
DRAWING

BIRKHÄUSER – PUBLISHERS FOR ARCHITECTURE
BASEL · BOSTON · BERLIN

CONTENTS

\\ Foreword _7

\\ Projection types _9
 \\ Top view (or roof plan) _9
 \\ Plan view _9
 \\ Elevation _10
 \\ Section _10
 \\ Three-dimensional views _11

\\ Principles of representation _14
 \\ Aids _14
 \\ Paper formats and paper types _16
 \\ Scale _18
 \\ Lines _19
 \\ Hatching _21
 \\ Labelling _22
 \\ Dimensioning _24

\\ Planning stages _30
 \\ Determining basics _30
 \\ Preliminary design drawing _30
 \\ Presentation plans _39
 \\ Design planning _42
 \\ Planning permission _50
 \\ Working plans _52
 \\ Specialist planning _63

\\ Plan presentation _66
 Plan composition _66
 Plan header _66
 Plan distribution _68

\\ Appendix _71
 \\ Symbols _71
 \\ Standards _74

FOREWORD

Buildings are not erected without plans, but must first be presented in plans and construction drawings. As a rule, the first steps consist of free presentations like sketches or perspective drawings, intended to establish the form and design of the building. This book begins at the point when these ideas have been developed, and the first sketches are turned into geometrically precise scale plans: technical drawings. These drawings provide an image of what will emerge in terms of design or construction, and their detailing process is thus an essential resource on the way to a finished building.

The "Basics" series of books aims to present information didactically and in a form appropriate to practice. It will introduce students to the various specialist fields of training in architecture, and transmit the basics in a compact and systematic way.

The "Technical Drawing" volume is directed at those commencing studies in architecture and civil engineering, and trainees in construction drawing and technical drawing. University courses in particular often require basic knowledge for the preparation of technical drawings, which students have to acquire laboriously for themselves. The difficulty lies in the large number of ISO standards that regulate construction drawings – the German DIN standards were largely the basis for international standards (e.g. for paper formats). Regardless of these general rules, however, there is no one correct way of preparing and creating a design or working drawing. Construction drawings always an act of self-expression by the person preparing them; they have a personal touch.

This book therefore provides the fundamentals required for the various plan types and drawings in the planning process – so that students are enabled to present their designs and ideas quickly and confidently through construction drawings.

Bert Bielefeld
Editor

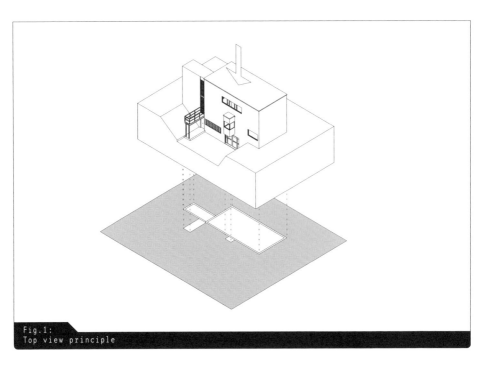

Fig.1:
Top view principle

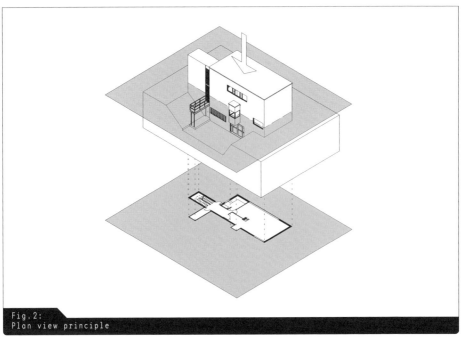

Fig.2:
Plan view principle

PROJECTION TYPES

Buildings are drawn in the form of sketches and free perspectives, but also using various structural drawing approaches. A fundamental distinction is made between top view and elevation for the exterior, and between plan view and section when drawing the interior of a building.

TOP VIEW (OR ROOF PLAN)

Top view drawings present a view or projection of the building seen from above. A top view (also often called roof plan) is important for the location plan, for example, which defines the building's position on the plot.

PLAN VIEW

In the same way, a plan shows a single floor of the building. Here a section is taken through the building at a height of about 1 to 1.5 m above the floor, to include as many apertures (doors, windows) in the masonry as possible. To make the drawing comprehensive, the heights of all the relevant structural sections (sill to floor height, aperture height, ground level, floor height) are given, as well as all the relevant horizontal dimensions. The height of the horizontal section may be changed to illustrate as many special features of the design as possible and to represent any windows that may, for example, be higher. (The different position of the window is then clarified by giving the sill to floor height.) For the direction of the plan, there are two basic possibilities:

_ The downward direction of view used in architects' plans (top view), which makes it possible to record room structures, form and size.
_ The reflected plan views from below showing construction elements that lie above the horizontal section level. – Structural engineers prefer this view, which shows the loadbearing construction elements in the ceiling above. › see chapter Specialist planning

Designating
plan views
› 🛈

Plan views are generally designated according to the floor they apply to, e.g. cellar floor plan view, ground floor plan view, 1st floor plan view, attic floor plan view etc. If it is not possible to identify floors clearly in a design, e.g. when floor levels are offset, the obvious thing to do is to name the plan views after particular levels: e.g. level -3 plan view, underground car park.

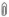

\\Hint:
As a rule, plans with top and plan views are
"northed", in other words, north is at the top
edge of the plan and is indicated by a north
arrow.

ELEVATION

Elevations (also called views in the ISO standards) show the outside of the building with all its apertures. Views of the cubature of a building provide information about its relationship to its environment, its form and proportions, and the construction type and material qualities where applicable. Along with the plan views and sections, elevations complete the overall design.

Elevations are parallel projections, seen from the side, onto a building façade. The projection lines run at right angles to the projection plane, so offset sections are not shown in their true size.

An elevation generally shows the immediate surroundings, with the lie of the terrain and links to any existing building development where appropriate.

Designating elevations

Elevations are identified according to their position on a point of the compass. The north arrow on the location plan and on the plan views defines the orientation of the building. Hence, the following designations are used for each of the four elevations: view north, south, east and west (or northeast, southwest etc.). If only two elevations are visible (as in terraced houses), they can also be defined in relation to the building's position on the plot, or the position of the development as a whole. But this means that only two sides are fixed unambiguously, e.g. the garden or courtyard side and the street side. The labelling of the elevations must be clear for anyone – even if they are not familiar with the area.

SECTION

A section is created by making a vertical cut through a building and considering this as a view in parallel projection. Sections are intended to provide information about floor heights, material quality and the building materials to be used for the planned building.

The section line must be entered on the plan view or all plan views. It is identified by a thick dash-dot line and the direction of view. Arrows and two capital letters of equal size fix the direction and the designation of the section. The section is taken in such a way that all the information

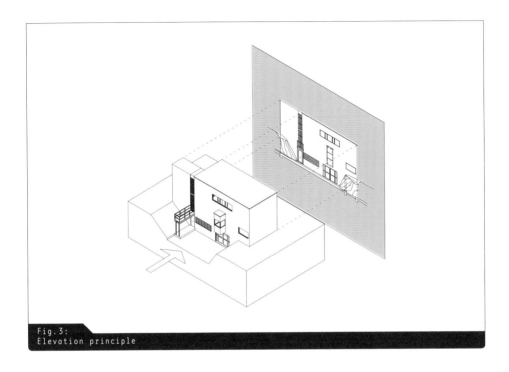

Fig.3:
Elevation principle

relevant to the building can be recorded, which means that the section line may deviate occasionally. This deviation must be at right angles, and must be identified in the plan view.

Elements of
a section

Important elements shown in a section include the structure of the roof, the floors and ceilings, the foundations, and the walls with their apertures. The section should also show access to the building via stairs, lift, ramp etc.

Designating
sections

Sections taken parallel through a main axis of the building are called longitudinal and cross sections. A longitudinal section cuts the building along the longer side and the cross section along the shorter. If more than two sections are taken, they are usually designated by capital letters or numbers. As the section lines on the plan views are identified by the same letters on both sides, the section designations are, correspondingly, section A–A, section B–B or section C–C etc.

THREE-DIMENSIONAL VIEWS

Axonometric
projections

Axonometric projections are plan views or views with a third plane added – height. They are generally used as three-dimensional views at the planning stage, and give a spatial impression of the building. They are

11

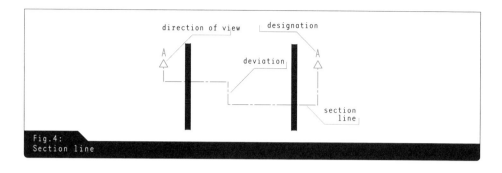

direction of view designation

deviation

section line

Fig.4:
Section line

used for construction plans only in exceptional cases, for example to show the design of a corner.

It is easy to develop three-dimensional views from a two-dimensional drawing. A distinction is made between different projections (even though the term "projection" is misleading here):

_ The "military projection", where the plan view is rotated through 45° at one corner and completed vertically by adding the heights.
_ The "architects' projection", where the plan view is again rotated at one corner – through 30° or 60°.

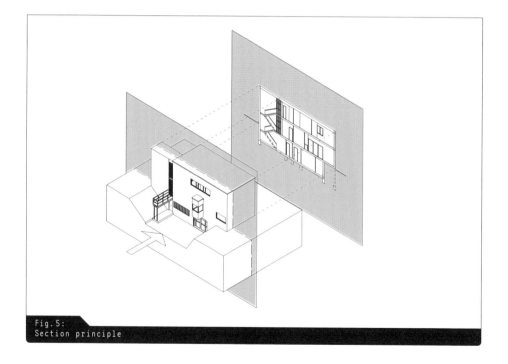

Fig.5:
Section principle

_ The "cavalier projection", where an elevation or section acquires a third dimension by the addition of lines at an angle of 45°.

It is possible to create a better three-dimensional impression by moving away from the right angle as a base. Isometric and dimetric projections are used to do this.

Isometric drawings place each of the two plan view axes at an angle of 30° to the horizontal base line, and the height axis is plotted onto the plan view axes. This means that the object represented is not so distorted as in the three methods given above, but the drawing must be constructed more elaborately.

For a dimetric projection the two plan view axes are placed at angles of 7° and 42°. The line lengths of the latter should be shortened by factors of 0.5 or 0.7.

Perspective drawings differ from axonometric, isometric and dimetric projections in that they do not present the lines lying on an axis as parallel, but in perspective. Since perspective drawings are not generally used as construction plans, but only for presentation purposes, they fall into the field of descriptive geometry and are not examined further here.

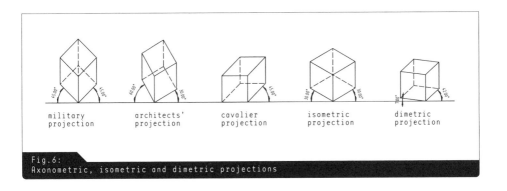

military
projection

architects'
projection

cavalier
projection

isometric
projection

dimetric
projection

Fig.6:
Axonometric, isometric and dimetric projections

13

PRINCIPLES OF REPRESENTATION

AIDS

Basically there are two different methods for producing construction plans:

_ Hand drawing
_ CAD

Drawing tables
Hand drawing is carried out either at special drawing tables fitted with a pair of sliding rulers set at right angles, which can be adjusted; or using drawing rails, which are screwed onto an existing desk-top and slid vertically on stretched wires. Both variants make it possible to draw lines parallel or at right angles.

Pens and pencils
for hand drawing

> ✎

Hand drawings are usually made with pencils or ink pens. Pencils are available in various hardness grades, which affect the thickness and visual effect of a line: the harder the pencil, the finer the line, because little lead is rubbed off onto the paper. So various grades of pencil are needed for drawings, to be able to make lines of different widths.

> ✎

Ink pens exist in various forms (e.g. with or without cartridges) and nib widths. The nibs mentioned in the chapter on lines are available individually.

Rulers and
set squares

A variety of rulers, protractors, triangles, set squares and stencils are available to make drawing simpler. Rulers, triangles and adjustable set squares are used to draw in the geometrical dimensions. Lengths on plans

✎
\\Tip:
Pencils ranging from grade B (soft) via F (medium) to H to 3H (various degrees of hardness) are used for construction plans. Harder pencils should be used first, to avoid smudging the softer, thicker lines.

✎
\\Tip:
Ink pens come with and without cartridges in various colours. The latter are cheaper in throwaway versions, but more expensive if a lot of drawing is to be done. The thinner the line produced by an ink pen, the greater is the danger that the pen may dry up if stored for a long time. Sometimes the pigments in the nib of the pens can be moistened in a bath of water. If lines that have already been drawn need to be removed, special ink erasers can be used. But careful scratching with a razor blade is quicker.

Fig.7:
Typical aids

are generally measured with a set square, a triangular ruler including six different scales with a length scale for each.

Stencils

Stencils are available for almost all typical drawing symbols (e.g. for furniture, electrical connections or bathroom facilities). There are also stencils for standard typefaces. All stencils are dependent on line thickness and scale.

CAD programs
> ◯

CAD drawings are made using a computer. You need a CAD (Computer Aided Design) program intended specially for construction drawing. Various programs are available on the market, but they differ considerably in ease of use, performance and price. Almost all providers offer student and school versions.

◯
\\ Important:
It makes sense to look at what several
providers offer before working your way into a
program. Prices vary considerably even between
the student versions, and it is also important
for fellow students or colleagues to use the
same program, so that working experiences can
be shared.

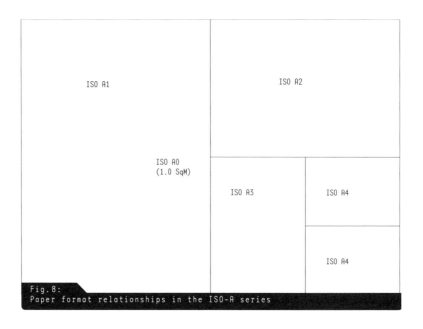

Fig.8:
Paper format relationships in the ISO-A series

PAPER FORMATS AND PAPER TYPES

Paper formats DIN 476-1 or ISO 216 define various paper formats based on a page
ratio of 1:√2. The advantage of this page ratio is that a large sheet can al-
ways be divided into smaller formats without waste.

There are various series within the DIN or ISO standards; the DIN-A
or ISO-A series is generally used for plans.

As losses occur when cutting to size and folding, sheet formats dis-
tinguish between trimmed and untrimmed sheets. There are also format
categories like DIN A3 Plus on the paper market, but these were created by
printer manufacturers and are not further standardized.

Table 1:
ISO/DIN series A-E (mm × mm)

	A–	B–	C–	D–	E–
2-0	1189×1682	1414×2000			
0	841×1189	1000×1414	917×1297	771×1091	800×1120
-1	594×841	707×1000	648×917	545×771	560×800
-2	420×594	500×707	458×648	385×545	400×560
-3	297×420	353×500	324×458	272×385	280×400
-4	210×297	250×353	229×324	192×272	200×280

Table 2: Untrimmed and trimmed DIN-A series papers (mm x mm)			
DIN	**untrimmed**	**trimmed**	**edge distance**
2-A0	1230×1720	1189×1682	10
A0	880×1230	841×1189	10
A1	625×880	594×841	10
A2	450×625	420×594	10
A3	330×450	297×420	5
A4	240×330	210×297	5

The paper formats described above are recognized and used in most countries; but in North America in particular, some inch-based formats are used that are based on ANSI standards.

Table 3: ANSI paper formats				
Series	**Engineers**	**Architects**	**Engineers**	**Architects**
A	8½×11	9×12	216×279	229×305
B	11×17	12×18	279×432	305×457
C	17×22	18×24	432×559	457×610
D	22×34	24×36	559×864	610×914
E	34×44	36×48	864×1118	914×1219
F	44×68		1118×1727	
	in×in		mm×mm	

Paper types Various paper types are distinguished, as well as paper formats. As a rule, tracing paper is used for hand drawings, as it has the advantage that other drawings can be placed underneath it to be traced. This considerably simplifies construction (e.g. of upper storeys or sections). Tracing paper also makes it possible to duplicate the original drawing simply, using blueprints.

In the inventory field, drawing films are often used, as they hold their shape even at higher temperatures, and thus measurements can be read off them reliably even after a long time.

For technical drawings made with CAD programs, normal white paper in roll or sheet form is usually used for plotting. Coated papers, or

photographic or glossy papers are often used for presentation drawings, as they have a high-quality surface.

SCALE

Every type of plan mentioned in the first chapter (Projection types) is a reduction in a certain ratio to the built reality, i.e. it is drawn on a particular scale. The scale used must be marked on every drawing, in the form of the word scale and two figures separated by a colon (e.g. Scale 1:10).

Definition
of scale
A scale describes the relationship between the dimensions of an element in a drawing and in the original size. A distinction is made between three principal scale types:

_ Original scale (scale 1:1) as the natural scale
_ Enlarged scale (scale x:1), in which one element is drawn larger than its natural size by a certain multiple
_ Reduced scale, (scale 1:x), in which one element is reproduced smaller than its actual size by a certain multiple

Thus, for example, a wall drawn on a scale of 1:100 will be one hundred times smaller than the original.

Typical scales
Reduced scales are almost always used for construction drawings, as the object represented is usually larger than the paper. As precision and detail in the design process increase, the reduction becomes less, so the object itself is represented as larger.

Location plans and rough surveys are often drawn on a scale of 1:500 (or 1:1000), design drawings on the scales of 1:200 or 1:100. For working plans, the scales of 1:50, 1:25, 1:20, 1:10, 1:5, 1:2 and 1:1 are used. › See chapter Planning stages

Converting
scales

›✎
If a wall 5.5 m long is to be represented on the scale of 1:50, its length must be divided by the reduction factor: thus, 5.5 m/50 = 0.11 m. The length drawn is thus 11 cm. It becomes more difficult when an object that is already drawn on a reduced scale has to be converted to a different one. If a door with a drawn length of 5 cm at a scale of 1:20 is then shown on a scale of 1:50, the two scales must be calculated against each other. Thus, the length is 5 cm *20/50 = 5 cm/factor 2.5 = 2 cm.

Scales for
CAD programs
CAD programs simplify the scale conversion problem. Here the building is usually input on a scale of 1:1, i.e. a wall 5.5 m long is drawn at this length. The drawing is additionally provided with an output or reference scale, which defines the scale on which the drawing will be printed and output later. Pen and lettering widths also adapt to this reference scale when viewed on the monitor, so that the ultimate result can be seen.

LINES

A technical drawing consists of lines that differentiate things accord-
ing to their type and width. Here a distinction is made between line types
and line widths, though their significance can vary from scale to scale.

Line types

The are four principal types of line: the unbroken line, the dashed
line, the dash-dot line and the dotted line, and other intermediate forms
can be developed from these.

Line widths

The following line widths are customary, although as a rule only
widths up to 0.7 mm are used: 0.13 mm, 0.18 mm, 0.25 mm. 0.35 mm, 0.5 mm,
0.7 mm, 1 mm, 1.4 mm, 2 mm.

Using unbroken
lines

The unbroken line is used for all visible objects and visible edges of
building sections; boundaries of sectional areas are also identified by un-
broken lines. When parts of a building are cut in sections on the scale of
1:200 and 1:100, unbroken lines 0.25–0.5 mm wide are generally used; on
scales from 1:50 a width of 0.7–1 mm is recommended. Unbroken lines for
auxiliary constructions, dimension lines or secondary top or plan views are
drawn more finely: 0.18–0.25 mm wide for a scale of 1:200 or 1:100, and
0.25–0.5 mm from 1:50.

Using dashed
lines and
dotted lines

Dashed lines are used for concealed edges of building parts (e.g. the
under-step in details of stairs) in line widths of 0.25–0.35 mm for scales of
1:200 and 1:100, and 0.5–0.7 mm for scales from 1:50.

Dash-dot lines define axes and section runs. As section runs need to
be immediately recognized on the drawing, they are drawn at a line width
of 0.5 mm for scales of 1:200 and 1:100, and 1 mm for scales from 1:50.
Axes, on the other hand, are usually drawn in lines 0.18–0.25 mm wide for
scales of 1:100 or 1:200, and 0.35–0.5 mm from 1:50.

19

_____ unbroken line

— —— — dashed line

·—·—·—·· dash-dot line

- - - - - - dotted line

_____ tip width 0.7

_____ tip width 0.5

_____ tip width 0.35

_____ tip width 0.25

_____ tip width 0.18

_____ tip width 0.13

_____ unbroken line 0.5 — borders of section areas

_____ unbroken line 0.35 — visible edges and outlines

_____ unbroken line 0.25 — dimension lines, auxiliary lines, reference lines

·— —— — — dashed line 0.35 — hidden edges and outlines

··—·——·—·—·— dash-dot line 0.5 — representing the section line run

·—·—·——·—·— dash-dot line 0.25 — representing axes

- - - - - - - - · dotted line 0.35 — building sections in front of or above the section plane

_____ unbroken line 1.0 — borders of section areas

_____ unbroken line 0.5 — visible edges and outlines

_____ unbroken line 0.35 — dimension lines, auxiliary lines, reference lines

·— — — — dashed line 0.5 — hidden edges and outlines

▬▬▬▬▬▬▬ dash-dot line 1.0 — representing the section line run

··—·—·—·—·— dash-dot line 0.35 — representing axes

- - - - - - - · dotted line 0.5 — building sections in front of or above the section plane

Dotted lines identify the edges of building section that can no longer be represented because they are placed behind the section plane. › see also chapter Projection types Here a line width of 0.25–0.35 mm is used for scales of 1:100 and 1:200, and 0.5–0.7 mm from 1:50.

HATCHING

Hatching is intended to simplify representing individual elements in drawings, and to make them more intelligible. Hatching appears in section plans (plan views, sections) and provides information about the nature of the representation, and the qualities of the materials and components used in the planning. When sections are taken through parts of a building the lines around them are usually filled in with hatching. Most statements about the way hatching is presented have been summed up in national standards. › see Appendix Basically, there is a distinction between section areas that are not dependent on the materials, such as diagonal hatching or filler areas, and material-dependent representations. › see Fig. 13 A material-dependent representation identifies the material to be used for the part of the building through which the section has been taken. In the preliminary design phase, walls with a section through them are often shown only by filled areas of material-independent diagonal hatching on the plan view, to emphasize the solid parts of the building. Material-dependent hatching is not usually deployed until the working plan stage (e.g. masonry or reinforced concrete), as the appropriate materials will already have been chosen at this point.

Principles of hatching

Hatching can be presented as lines, dots, grids or geometrical figures. If the interfaces of several parts of the building are juxtaposed, then the direction of the hatching will change as well. Hatching is usually drawn at 45° or 135°.

\\Hint:
The above-mentioned line widths should be understood as guidelines, because of the current use of CAD. Today's CAD programs offer users pen categories that can be tailored to individual needs. So at times smaller line widths are used than in hand drawings. Test printouts should however be made at the beginning of a drawing to be able to estimate the effect of the line width on an output scale, as the on-screen effect often does not reflect the printed reality because of zoom functions and presentation that is independent of scale.

\\Hint:
In CAD programs hatching can be scaled in such a way that it makes visual sense for every output scale. In this context, the terms scale-dependent and scale-independent hatching are used.

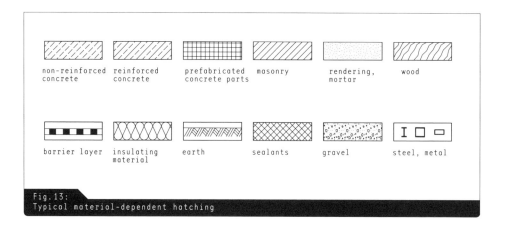

non-reinforced concrete reinforced concrete prefabricated concrete parts masonry rendering, mortar wood

barrier layer insulating material earth sealants gravel steel, metal

Fig.13:
Typical material-dependent hatching

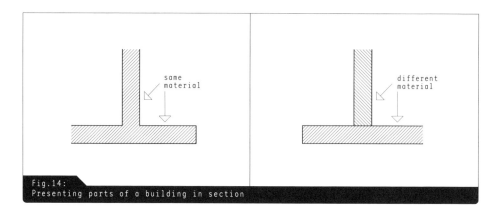

same material

different material

Fig.14:
Presenting parts of a building in section

The basic hatching for representing a material-independent inter-face of part of a building is drawn with an unbroken line at an angle of 45°. Narrow sections, such as profile cross-sections in steel construction, should be black for greater intelligibility.

LABELLING

Appropriate labelling is needed to produce a complete drawing, as well as lines, areas and hatching. The degree of detail in the labelling is chosen in relation to the scale; it is there to support the technical drawing (e.g. for stating dimensions, numbers of rooms, information about material etc.).

The chosen typeface must be unambiguously intelligible, so a standard typeface is usually chosen. Standard type (also called ISO type) is the name

for an internationally used type of labelling using upper and lower case. Standard type is subdivided into four different forms on the basis of type sizes and type angles. Thus, a distinction is made between two type widths:

Type form **A** – narrow, with a line width of height/14
Type form **B** – medium wide, with a line width of height/10

and two type angles:

Type angle **v** – vertical, with letters placed vertically to the direction of reading
Type angle **i** – italic, with letters at 75° to the direction of reading

Using type
styles

The best-known of the standard type forms used is a combination of type form **B** at the appropriate angle, producing **Bv** (medium wide line, vertical) and **Bi** (medium wide, italic).

Standard type forms are available as stencils for hand drawings in all the usual scales and type widths. Architectural drawings that are still produced by hand use building type. This is restricted only to upper-case letters developed from the shape of a square.

CAD programs can usually use the full range of fonts offered by the operating system. But here, too, it is better to choose a font in common use, as the next user should also have the font installed when data are exchanged.

A B C D E F G H I J K L M N O P R S T U V W X Y Z
a b c d e f g h i j k l m n o p r s t u v w x y z
1 2 3 4 5 6 7 8 9 10 [(! ? : ; - =)]
vertical type form

A B C D E F G H I J K L M N O P R S T U V W X Y Z
a b c d e f g h i j k l m n o p r s t u v w x y z
1 2 3 4 5 6 7 8 9 10 [(! ? : ; - =)]
italic type form

Fig.15:
Standard types Bv and Bi

Lettering is always positioned either horizontally to the direction in which the plan is to be read, or vertically turned anti-clockwise (and thus readable from below or from the right).

DIMENSIONING

Principles for dimensioning

Regardless of the fact that plans are drawn to scale, all the relevant dimensions must be clearly defined.

Regardless of whether plans are drawn true to scale, all the relevant dimensions must be defined clearly. This is done with the aid of dimension chains, relative elevations or by indicating specific dimensions. Dimension chains are sections arranged next to each other and provided with individual dimension information. Relative elevations are defined heights for particular points (for example the top edge of a floor slab).

Guidelines for entering dimensions on drawings are laid down in specific national standards (see appendix).

Dimension chains

Structure of a dimension chain

A dimension chain is made up of the following elements:

_ Dimension line
_ Auxiliary dimension line
_ Dimension limits
_ Dimension figure

Dimension limits

Dimension line, dimension limit lines and auxiliary dimension lines are always unbroken lines. The dimension line is placed parallel to the part of the structure to be dimensioned, with the auxiliary dimension line vertical to the dimension line, defining the axis, edge or line being dimensioned.

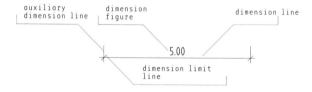

auxiliary dimension line dimension figure dimension line

5.00

dimension limit line

Fig.16:
Elements of a dimension chain

24

Fig. 17:
Example of dimension limits

Dimension limits define the external point of the dimensioned length on the dimension line. Even though in principle the auxiliary dimension line defines this, it is often unclear for intersecting lines on drawings whether the thick line for a wall through which a section has been taken also contains the dimension limit.

Dimension figures in dimension chains
For this reason the dimensions should be clearly demarcated. According to the scale, either a diagonal line or a circle is used (e.g. design with lines, working plans with circles and detail planning with small dimensions chains with closed circles), but in principle a free choice can be made. Dimension limit lines are drawn at 45° from bottom left to top right seen from the direction of reading.

The dimension figure equals the length of the structural element to be dimensioned and correspondingly also identifies the spacing for the dimension limits. For distances larger than 1 m the figure is given in the metre unit (e.g. 1), for distances smaller than 1 m the unit is the centimetre

25

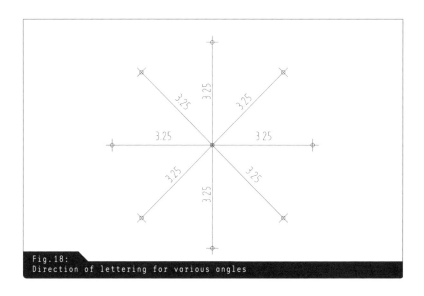

Fig.18:
Direction of lettering for various angles

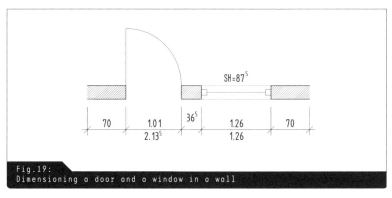

Fig.19:
Dimensioning a door and a window in a wall

(e.g. 99 or 25). For millimetres the figures are raised (e.g. 1.25^5 or 36^5). Units such as m or cm are not given.

Position of the dimension figure

As a rule, the dimension figure is placed above the dimension line and centrally between the dimension limits. For aperture dimensions the height of the aperture is also shown under the dimension line. › see Fig. 19 If there is an additional sill (e.g. for windows), the sill height is given directly on the inside of the aperture (e.g. with SH or S = 75).

Dimensioning inside the dimension line is uncommon: as an alternative to dimension figures above the dimension line, the dimension figures may also be inscribed directly into the line, omitting that part of the line.

26

Problems occur when the distances between the dimension limits are very small, i.e. if there is little room for the figure (e.g. for lightweight walls and installations in front of walls). Here, the figure may be placed directly beside the dimension limit. › see Figs. 25–27 Dimension figures and dimension lines must not overlap, to maintain legibility.

Height dimensions

Height dimensions in elevations/sections

Height dimensions cover floor, sill and clearance heights and relate to a level ±0.00. This is normally set as the upper edge of the completed floor structure in the entrance area. The surveyor surveys and relates this point to mean sea level or zero level (ZL), so that the building is correctly positioned in terms of height. Hence the reference of ZL and ±0.00 should be defined on every plan. All height indicators then relate to the starting-point ±0.00 in terms of + and − signs.

A distinction should be made in the drawing between height dimensions of plan or top views and sections or elevations.

Height dimensions on plan views

Height dimensions in elevations and sections are given by height indicators: the graphic symbol for a height indicator is an equilateral triangle drawn directly with the height figure into the drawing of the structural element or onto an additional dimension limit line (e.g. outside the building).

For shell dimensions the triangle is usually solid black; for completion dimensions it is left as an outline triangle. Thus, the dimensions given can be clearly and correctly allocated even on small drawings.

Angle dimensions

Height dimensions on plan views and top views are also represented by triangles (solid for shell construction, outline for completion elements), but most commonly, circles with a line passing through them are used, with the completion dimension above the line and the shell dimension below it. Here, too, the dimensions can be directly identified by filling the semicircles appropriately. Another classification option is to use

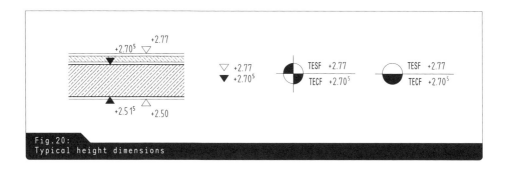

Fig.20:
Typical height dimensions

27

the labelling TECF (top edge complete floor) and TESF (top edge shell floor).

Angle and curve dimensions

If structural elements are not at right angles to each other, the relevant angle must be indicated. This is usually done by stating the number of degrees and the typical symbol ⊀, but it can also be done by using a segment of a circle with arrows on the ends and the number of degrees in the middle.

For rounded structural elements, circular dimensions should be given, for example to define the developed length of a curved reinforced concrete wall. This is necessary, among other things, for determining and calculating the dimensions (continuous metres of wall, baseboard etc.). The dimension chain for a circular dimension consists of a circle parallel to the actual curve (i.e. dimension circle and curved wall have the same centre). The dimension limits can be used as explained above for circular dimensions, or arrows can be placed at the ends of the dimension circle.

Individual dimension indications

If individual dimensions must be indicated, they are usually written directly onto the particular structural element. They can also be allocated by abbreviations (e.g. SH for sill height), or symbols (e.g. Ø for diameter or □ for a rectangular section). Radii have a capital R before the dimension figure, screws and threaded rods an M. For simplification, height and width may also be given in abbreviations (e.g. W/H 12/16 for a wooden beam 12 cm wide and 16 cm high).

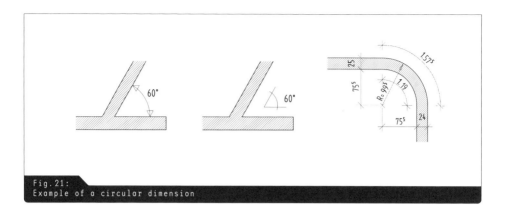

PLANNING STAGES

Construction drawings can be divided into two groups. The first describes the phase in which ideas are established: from design to planning permission.

The second group includes the construction phase with its associated drawings to accompany the building work. Thus, a distinction is made between pre-design, design, drawings with building particulars, and working drawings.

The corresponding planning documents contain specific information for a particular target group. Planning documents can provide a decision-making basis for clients or local authority building departments; specialist planners may use them as a basis for their own plans; and they can contain concrete building instructions for the specialist firms carrying out the work. The scope and precision of a plan derive from the purpose, nature and scale of a drawing. The less it is reduced, the larger the structural elements it shows are, and thus the dimensioning and labelling become more detailed.

DETERMINING BASICS

Land registry plans Land registry plans (usually on a scale of 1:1000) of towns and municipalities are available to provide an overview or basis for a design; they may be slightly imprecise in their indications of dimensions.

As-built plans If an existing building is being converted, its current state must be surveyed and presented in a drawing as a basis for the work. The subsequent planning phases are based on this. The degree of elaboration, and thus the precision, of as-built plans depend considerably on the use for which the building is intended. If a small extension is to be added to an existing home without particular demands on quality of detail, it is usually enough to record the relevant rooms in terms of width, length and height. If monument preservation measures have to be taken in a listed building, the dimensions must be recorded in detail and complemented with precise indications about surfaces and distinctive features.

PRELIMINARY DESIGN DRAWING

Purpose of preliminary design drawing A concept is turned into an overall presentation in the form of a drawing (a plan) in the preliminary design drawings. A distinction is also made in this phase between construction drawings for future planning and concept drawings to explain an idea to a client. The aim of preliminary design planning is to clarify and explain the idea behind the design. Preliminary design plans thus express the planner's design approach and allow a great deal of latitude in terms of presentation. On the other

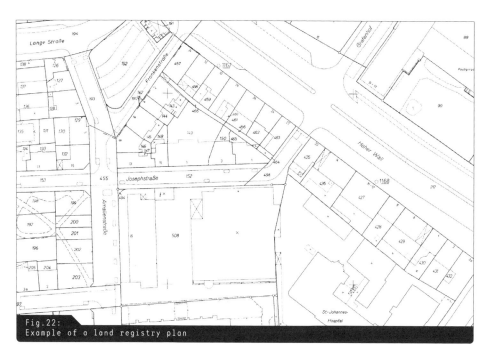

Fig.22:
Example of a land registry plan

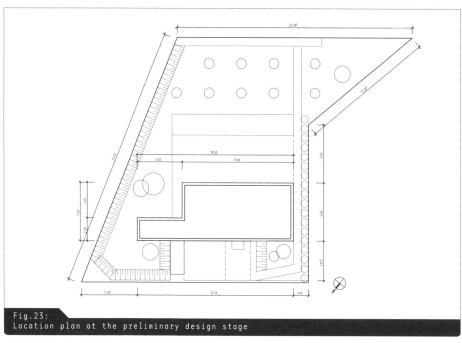

Fig.23:
Location plan at the preliminary design stage

hand, even a preliminary design plan may be consulted when clarifying information about the building with the relevant authorities. For this reason, it forms the basis for a preliminary decision by the building authorities.

Preliminary design drawings provide only the most necessary information about the shape and size of the building. These drawings are mainly drawn on a scale of 1:200, or 1:500 for large projects. Location plans are reduced even further (scales 1:500 or 1:1000).

The location plan shows the building on the basis of the plot dimensions in the context of its surroundings. Its location on the plot is defined; hence the term location plan. The information entered gives a general view of the building's size and orientation, the nature of the terrain and its use, and where necessary includes the adjacent plots as well.

One sensible starting-point for drawing up further construction plans is a ground floor plan view matching the location plan. Starting with the ground floor plan view, the best way to develop the floors above is to base them on the plan view that has already been prepared (both at the drawing board and in a CAD program).

After drawing up the plan views, it is relatively simple to construct the sections. The chosen section line is first drawn into the plan view, and

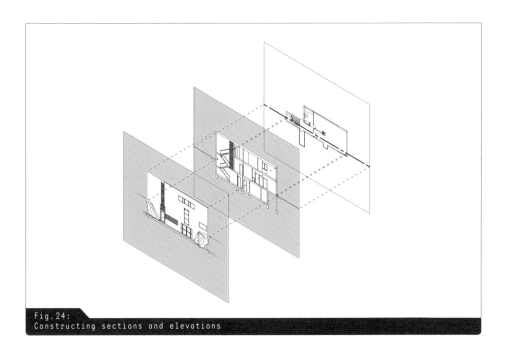

Fig. 24:
Constructing sections and elevations

then turned to be horizontal and form the basis for the section. It forms the zero line of the section, i.e. the entrance level for the building. All heights are developed vertically upwards on this line (upper floors) and downwards (basement floors): to do this, the edges of the intersected walls are simply extended to an appropriate level in relation to the zero line. Elevations should be constructed only on the basis of the heights marked in the sections. It is simplest to trace the external outlines of the sections and add windows, doors and ground connections by placing plan views underneath. > see Fig. 24

Representing
structural
elements
The aim of the preliminary planning is to clarify and illustrate the cubature of the building, the distribution of space and the way the building fits in with its surroundings, in terms of a provisional arrangement and provisional dimensions. Structural elements are usually presented without indication of materials, so that at first it is only possible to identify which elements are intersected.

In elevations, all the visible edges are represented by an unbroken line. The thickness of the unbroken line depends on scale, relevance (walls are more important than a door handle, for example) and the degree of detailing in the building. Thus, the outlines of the external walls and their apertures are emphasized most strongly.

Finishing details such as toilets, kitchen or furniture are given in top view and elevation, to illustrate the design. Furnishings are important to inexperienced clients as a yardstick for size ratios in housing construction in particular, so that they can understand proportions and the size of rooms.

Establishing
scale
Representing trees, people and the external areas clarifies how the building fits into its surroundings while providing a background that does not conceal information. Proportions and scale can be conveyed better by showing objects whose size or proportions are familiar even to the unpractised eye. This is called establishing scale, and the individual items are scale-establishing objects. These "extras" are mostly used only at the preliminary and design stages, and for competition and presentation drawings.

Dimensioning
Dimensioning is restricted to rough measurements in preliminary design planning. In plan views, external dimensions and important room dimensions are given in order to make room sizes and overall measurements comprehensible. Individual projections and recesses, and door and window apertures, are not usually dimensioned.

In elevations, only important height dimensions such as eaves and ridge height are given; in sections the room or floor heights appear as well.

Labelling
Labelling is also restricted to simple identification of rooms by function and the estimated areas of the rooms in square metres.

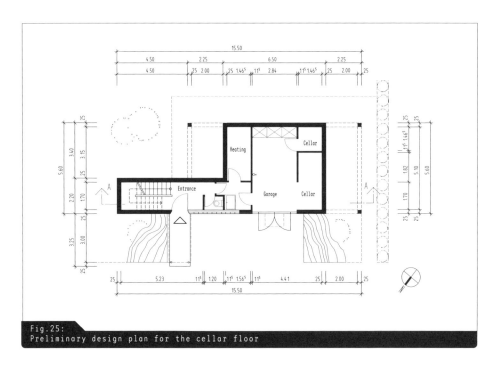

Fig.25:
Preliminary design plan for the cellar floor

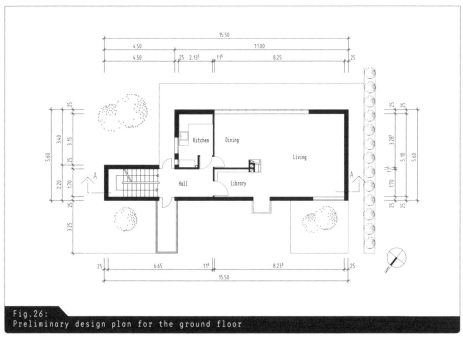

Fig.26:
Preliminary design plan for the ground floor

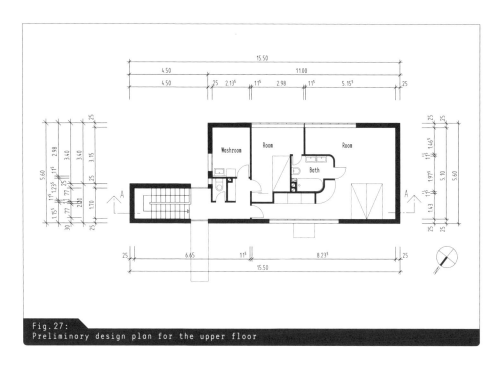

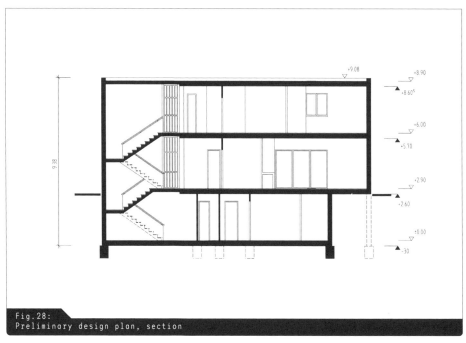

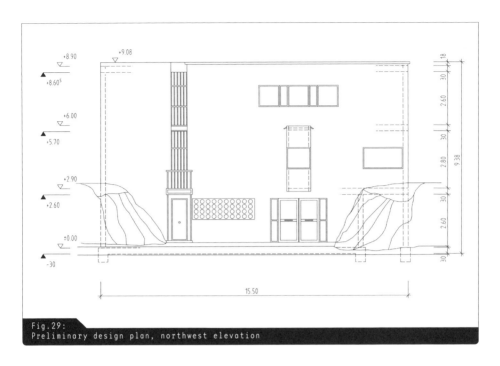

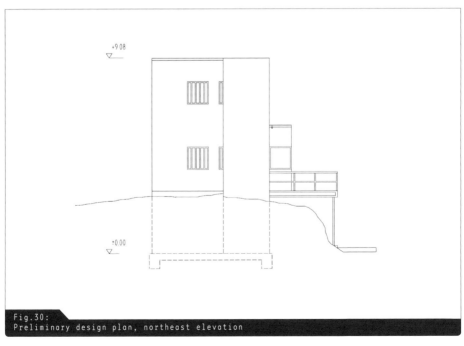

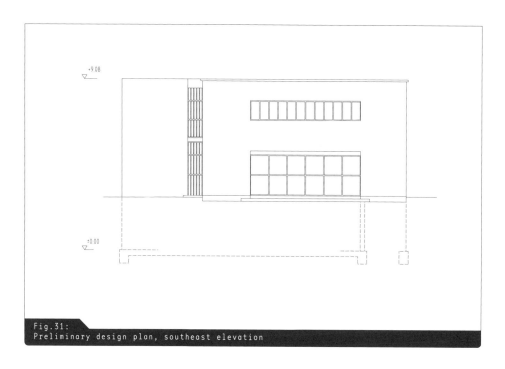

+9.08

±0.00

Fig.31:
Preliminary design plan, southeast elevation

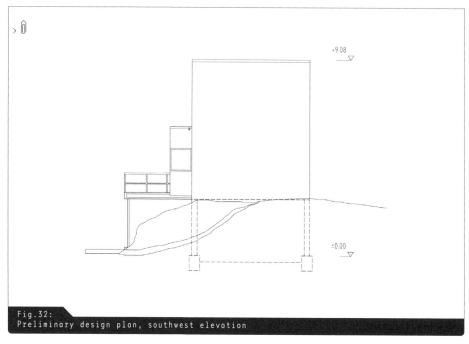

+9.08

±0.00

Fig.32:
Preliminary design plan, southwest elevation

The building presented here is a design for an
early residential building in Vaucresson (1922)
by Le Corbusier. The plans were copied by the
authors on the basis of Le Corbusier's plans,
but dimensions and details have been changed
and adapted, or measurement chains completed,
to illustrate the relevant points here. Some of
the dimensions for doors, toilets etc. are no
longer admissible under current regulations and
should therefore not be used as models for the
reader's own construction drawings.

It is helpful, particularly in the submission
phase for student work or competitions, to draw
a short list of headings summing up the key ele-
ments of the design idea and translating these
into pictograms.

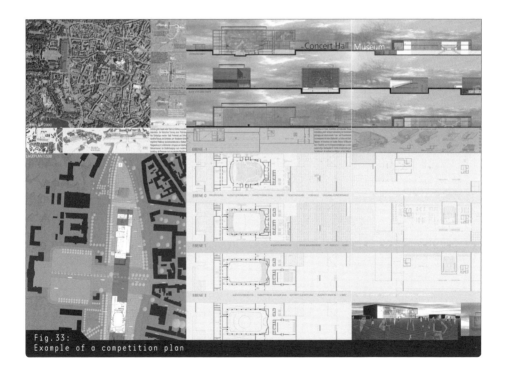

Fig. 33:
Example of a competition plan

PRESENTATION PLANS

Client
presentation

To present a design, presentation plans are prepared independently of the classical construction drawings. Presentation plans are usually drawn up after a preliminary design has been completed, so that this can then be confirmed for further planning purposes: presentation plans are intended to persuade a particular target group of the design idea and the concept, so they should be devised with this purpose in mind.

If, for example, an inexperienced client is unable to associate a three-dimensional idea with a technical, two-dimensional drawing, then it makes sense to underpin his sense of space with three-dimensional representations or perspective views.

The client may have to present the design to a third party, and may need visual materials to help persuade them. These can be three-dimensional presentations or perspective views, or graphic presentations of zoning, pathway links, work areas or similar items on the basis of plan views and sections.

Architectural
competitions

›✎

If planners or students take part in competitions, their own ideas must be presented in such a way that it makes a clear impact on the jury. As juries are usually made up of a mixture of experts and laypeople, the

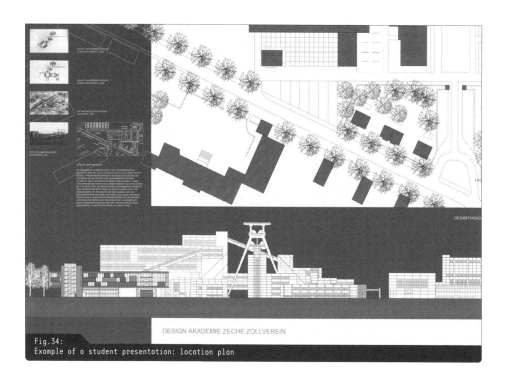

Fig.34:
Example of a student presentation: location plan

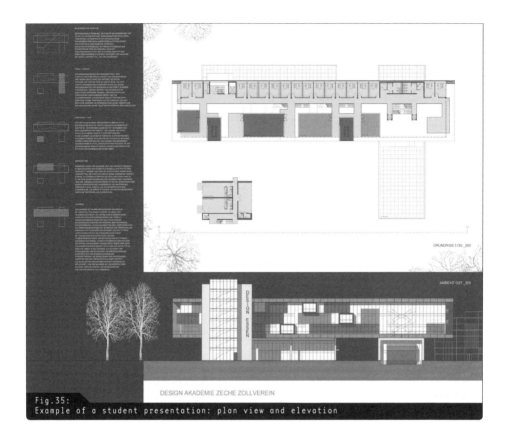

Fig. 35:
Example of a student presentation: plan view and elevation

needs of both groups should be taken into consideration. As a rule there is little time available for judging the entries, and so everyone looking at the submissions needs to understand the individual designs quickly. It is also important to make your design stand out from those submitted by the other entrants.

When a student design is presented, the college or university lecturer responsible should be able to understand his or her students' ideas, i.e. the presentation should convince a qualified expert with appropriate skills in terms of abstraction and imagination. For this reason, more conceptual approaches tend to be chosen for student submissions than would be used for presenting ideas to a client. For example, if this is desirable in graphic terms, it is possible to omit the scale-establishing features that are needed for the layperson.

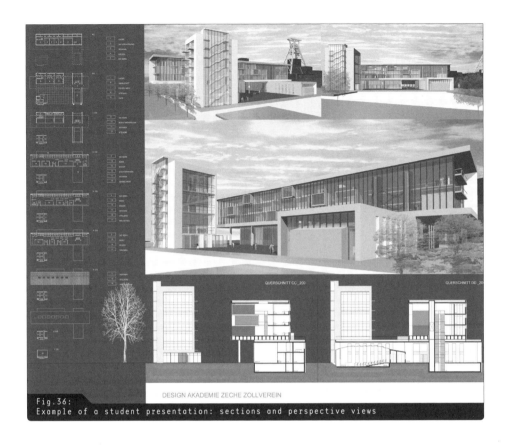

Fig.36:
Example of a student presentation: sections and perspective views

Content of
presentation
plans

As well as classical elements such as location plan, plan views, sections and elevations, presentation plans often contain three-dimensional representations of interiors and exteriors. Pictographic elements may also help to represent the design idea or the functional context of the design.

Devising
presentation
plans

The plans to be submitted are usually confined to one particular scale. For presentations, there is otherwise a greater degree of freedom than for technical construction drawings. Dimensioning can be reduced to a minimum, structural elements represented graphically or the whole scope of the drawing can be reduced essentially to elements of composition. – There are no limits on creativity. It is important to keep in mind the clarity and accessibility for the person looking at the work, and to devise the presentation appropriately.

41

DESIGN PLANNING

Purpose of
design
planning

Design planning is a further development of the preliminary planning stage. Now the architect and the client finally define the geometry and dimensions of the design for the building permission plans that will follow. The design plans must therefore show all the important elements that are relevant for the planning authorities' consideration. This phase also addresses planning in other fields like structural engineering and domestic services, which means that all the fundamental structural information (e.g. loadbearing walls) must be visible.

Scale

Design plan views for housing are usually drawn on a scale of 1:100, and for very large buildings on a scale of 1:200 or 1:500 if necessary. For example, if the plan view of a large industrial hall were presented on a scale of 1:100, a very large number of AO sheets would be needed, so it would no longer be possible to take in the design as a whole. But, as explained above, since the design plans are intended to provide a comprehensible and useful basis for further discussion, it makes sense to choose a less refined presentation on a higher scale.

Showing walls

Even at the design planning stage, material-dependent hatching can be used for representing walls, in order to define the material, e.g. a reinforced concrete, masonry or dry construction wall. Line widths distinguish between loadbearing and non-loadbearing walls. It is not usual to show wall surfaces (e.g. interior rendering) at the design planning stage. All the doors and windows should be entered on the plan correctly, in such a way that the aperture dimensions and, where applicable, the sills can be seen. The direction in which doors open should also be shown at the design planning stage, to indicate the flow of movement in the building.

Foundations are indicated in consultation with the structural engineers, along with their construction details (individual foundations, ice wall, foundation strip), with their correct depths and widths. If it is necessary to explain the section, invisible parts can be shown as dashed lines.

Showing floors
and ceilings

Sectional drawings of floors and ceilings are made up of the shell floor including hatching to show material qualities and the completed floor as an upper edge, in order to define the height of the structure.

Showing
invisible
elements

Since the horizontal section plane in a plan view lies 1.5 m above floor level (see above), structural elements placed above it are not visible in the plan. But to understand the geometry and the space it is often necessary to show these elements as well. They can be beams or girders, which divide a space into several section visually (the dimensions of the beams or girders are shown directly on the plan view drawing, e.g. B43/35); or stairs, whose upper run should be shown, with a junction point to under-

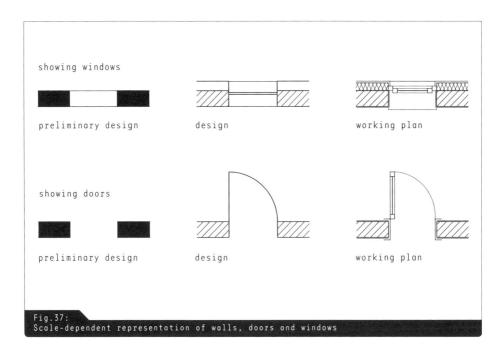

showing windows

preliminary design design working plan

showing doors

preliminary design design working plan

Fig.37:
Scale-dependent representation of walls, doors and windows

stand the geometry of the steps. The same applies to sections, for example in the case of covered mezzanine floors or invisible stairs. In elevations, the loadbearing walls and floors inside the building envelope can be indicated with a short dashed line.

Additional information in elevations

The following elements can also be shown in the elevations (views): windows with divisions and opening mode, blind cases BC), height of window apertures, balconies, sills, protrusions and recesses, roof forms.

Site layout

The existing and planned layout of the site before and after building should be drawn in as precisely as possible, as it is relevant for the building's entrances and exits, the necessary earthworks and the building inspection authorities. The building's height systems are also developed from this.

Showing stairs and ramps

Stairs are defined in design plans by stating the number of steps, risers and treads (e.g. 10 risers of 17.5/26). Flights of stairs are also identified by continuous lines, with the starting-point (starter) identified with a circle and the end-point (exit) with an arrow. Ramps are identified by two lines taken from the start of the ramp to the central point of its upper end.

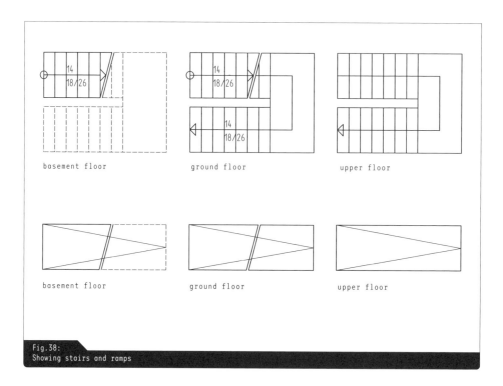

basement floor ground floor upper floor

basement floor ground floor upper floor

Fig.38:
Showing stairs and ramps

In sections, the stair structure is shown as simply as possible, so that the geometry of the stairs can be understood: a distinction is made between concrete, closed or open steps in wood or metal as stairs with or without landing.

Dimensioning plan views

Dimensioning in design planning is intended to define the geometrical coherence of a building and the rooms it contains. The exterior dimensions of the building are entered first – as in preliminary design planning – including all external cladding and rendering. This makes it easier to determine the gross floor area, the gross space enclosed and the building's position in the location plan or on the plot.

The second step dimensions all the external doors and windows, and ideally an additional dimension chain is added for the interior position of the windows. › see Fig. 39 Thus, all the apertures can be defined in their geometrical relationship with the elevation of the building and in relation to the spatial impact of the exterior wall. Any possible shifts between interior and exterior axes or possible window rabbets can be seen and planned.

44

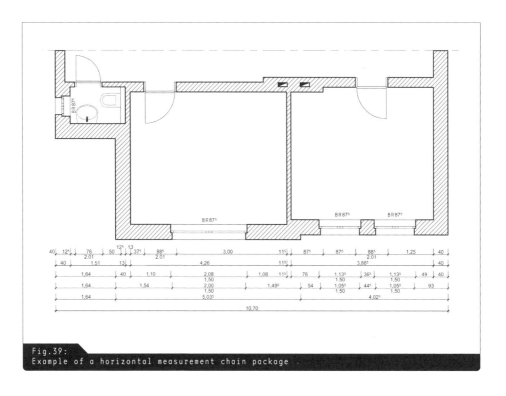

Fig.39:
Example of a horizontal measurement chain package

The next step records the interior spaces with the length and width. This is essential for calculating room and apartment sizes, and is useful for the later user as a basis for furnishing. It thus makes sense to give individual dimension chains for the overall room size and the wall features with door(s). The heights of apertures (doors, sills and windows) are indicated as described above with an additional figure under the dimension line, and sill heights are given for windows. Planners should pay particular attention to arrange dimension chains in a comprehensible order and on clearly distinguishable axes, so that the plan is easily intelligible. A typical sequence for a house works from the outside inwards:

1st dimension chain: total exterior dimensions (where applicable, additional dimension chain for walls with protrusions or recesses)

2nd dimension chain: exterior dimensions with all apertures (doors, windows, projections etc.)

3rd dimension chain:	interior dimensions of apertures with all sectioned walls
4th dimension chain:	room dimensions for the rooms behind the exterior wall
5th dimension chain:	interior walls of the rooms with doors, recesses, corners and passageways
6th dimension chain:	room sizes for the interior rooms
7th dimension chain:	etc.

 If it is relevant to the design (e.g. in industrial buildings) the axis dimensions are placed furthest from the drawing and defined with continuous numbers to the right or left of the plan view and with continuous letters above or below the plan view.

As well as giving lengths and widths, information about heights must be included in a plan view. Only this way can the plan view be clearly built into the height levels on the plot and in the building. If the plan view does not show height gradations, these heights are often defined just once, in the entrance area, and the section is used for detailed heights. For this reason, the height dimensions should be added to the plan views only when the section is complete.

Dimensioning sections

The construction and storey heights are the most important features of sections, as these are needed to complete the plan views. Height indicators are normally used for this › see chapter Principles of representation/dimensioning, supplemented by dimension chains. The height indicators show absolute

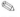

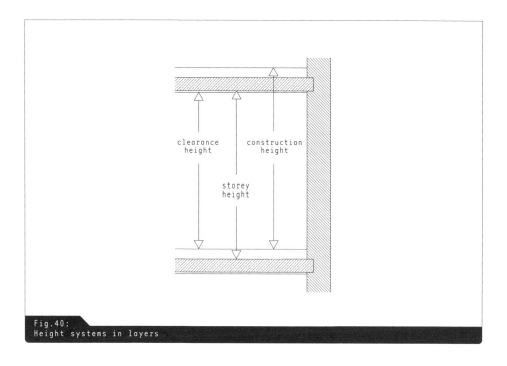

heights (related to zero level), and the dimension chains give individual construction and room heights. For example, height indicators in the roof structure give information about heights in the loadbearing structure and for the overall height of the roof structure (ridge height, attic height). When giving storey heights we distinguish:

_ storey height: height from top edge to top edge of storeys in sequence
_ clearance height (CH): height between top edge complete floor (TECF) and the lower edge of the complete floor above (where applicable, lower edge of the rendering or suspended ceiling)
_ construction height: distance between the top edge of the shell floor (TESF) and the bottom edge of the shell floor above (BESF)

The following sequence should be followed when arranging the dimension chains (as in the plan view):

1st dimension chain: overall exterior dimensions (where applicable, additional dimension chain for recesses or protrusions)

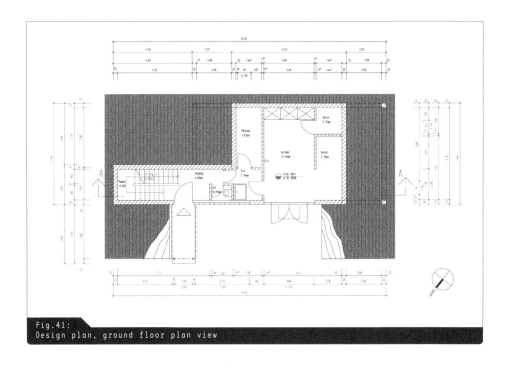

2nd dimension chain: external dimensions with all apertures (doors, windows, sill height etc.)

3rd dimension chain: interior dimensions with all apertures (doors, windows, sill heights etc.)

4th dimension chain: clearance heights

5th dimension chain: etc.

Dimensioning
elevations

Elevations (views) are dimensioned with height indicators. It may be necessary to use dimension chains for completeness when dealing with larger buildings.

As for a section, the height indicators relate to the zero line at complete floor height on the ground floor, and additional information about height at zero level (ZL) can be appended.

Additional ZL information may be included, particularly to represent street height and the lie of the terrain.

Labelling

As a rule, only distinctive elements, for example the top edge of the land and the roof edge, are given in elevations at the design stage.

48

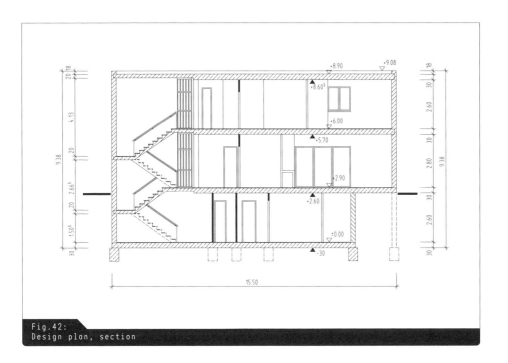

Fig.42:
Design plan, section

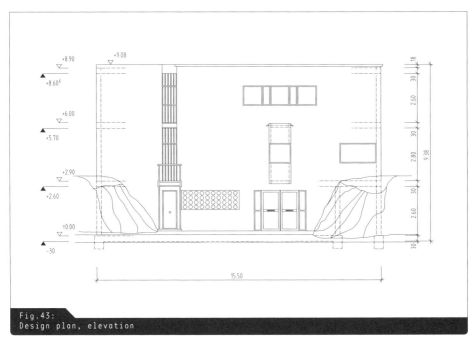

Fig.43:
Design plan, elevation

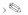

Additional information on the plan view drawing is given by room identifiers. These contain room numbers and/or room names (WC, living room etc.) and where applicable the room area in square metres. The entrance to the building is often identified by a solid black triangle, to make it easy to find on the plan.

Inclines such as rises and drops are identified by a height dimension and an angle, and in sections the percentage or degree is given, complemented by a directional arrow: e.g. roof pitch to the right, 45°). A north arrow is also drawn in, so that the light quality in the various rooms can be assessed, and so that the elevations can be identified.

PLANNING PERMISSION

In this phase, the location plan and the design drawings are completed by adding information in accordance with the regulations of the relevant planning authorities. Various requirements are imposed according to the nature and size of the planned building. In principle, it is very easy to turn designs plans into planning permission submissions.

Official
location plan

Location plans, in particular, must often be drawn up by a publicly appointed surveyor or the local survey office. The responsible authorities should be asked to explain what is required before an application for panning permission is submitted. For an official location plan, written and drawn parts are distinguished. The location plan drawing is usually on a scale of 1:500, but scales 1:1000 or 1:250 are possible for very large or very small projects. The content of the location plan is usually in black and white, but colours may be used for areas and boundaries where applicable.

A location plan should contain the following information:

_ Location of the building plot relating to points of the compass, north arrow
_ Existing buildings identifying use, number of floors, roof shape (ridge direction)
_ The planned building identifying exterior dimensions, heights relating to zero level, number of storeys, roof shape
_ Exterior dimensions of existing buildings and new buildings
_ Information on type of use for the areas that are not built on, such as garden, parking space, playground, terrace etc.
_ Statement and verification of distances from adjacent plots and to public areas (often in a separate plan showing distances apart)
_ Marking and demarcation of areas with building restrictions
_ Position of supply lines (water, electricity, heat, radio/telephone)

The location plan is supplemented by the following written information:

_ Scale
_ Details of street name and house number, owner, plot designation (boundaries, open fields, parcels)
_ Area dimensions, boundaries relating to land registry
_ Information about existing trees, especially if subject to nature conservation or tree protection orders
_ Information about areas with building restrictions and their use

If the building plot is part of a development plan its provisions must be complied with; these are usually shown by graphic symbols.

Building in existing stock

If the plan is not for a new building, but an extension or conversion, a clear distinction must be made between demolition and new construction in the plans. As a rule, as-completed plans are drawn at the beginning of the project, to plan conversion and demolition measures. If a great deal of the building is to be dismantled, it is also recommended that separate demolition plans be drawn up, to be developed further as working plans and used as a basis for the demolition work. Demolition is further identified by crosses at an angle of 45° and dashed in on the plan view and section. In addition, existing building, demolition and new construction are coloured on the plan:

Black: old, existing sections to be retained
Red: new sections to be added
Yellow: sections to be removed in the course of the building programme

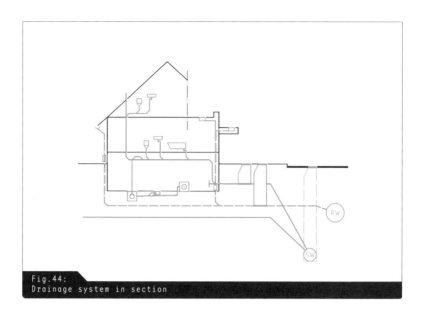

Fig.44:
Drainage system in section

Generally speaking, the desired presentation should be discussed with the planning authority.

Drainage
drawings
Drainage plans identifying the course of the drainage pipes are drawn to show drainage for sanitary facilities like WCs or kitchens and the exterior drainage of roof surfaces. They show the fall pipes and pipes connecting to the facilities in plan view and section. The pipes are identified by their diameter (e.g. DN 100 = interior diameter 100 mm), according to which wall-mounted installations, plumbing shafts etc. are dimensioned.

WORKING PLANS

Purpose of
working plans
Working plans are intended to provide information that can be used to construct the building precisely. Hence, the working drawings must contain all the individual items of information needed to complete the building. These include the architects' plans, which should also be complemented by plans from other specialists, e.g. heating, sanitary pipework, loadbearing structure, fire protection etc.

The working drawings include two subgroups laying down the scale and degree of detail in the planning. The working plans are on the scale of 1:50 and the detailed plans on scales of 1:20 to 1:1. Fundamentally a distinction can be made between the following working plans – not necessarily a complete list:

_ Working plans scale 1:50: these consist of plan views, elevations and sections representing the building as a whole or parts of it.
_ Façade sections scale 1:50–1:10: as a rule, the façades are shown in more detail with sections, interior and exterior views, in order to fix the relationship with other parts of the building in structural and geometrical terms.
_ Installation drawings scale 1:50–1:20: special installation plans are drawn for individual services. These include screed plans, tiled surfaces, floor covering plans, plans for dry construction and grid ceilings etc.
_ Detail plans scale 1:20–1:1: detail plans show individual structural points or connection with every element, in detail.
_ Site installation plan, where applicable

Working plan
presentation

The planner must translate the design planning into valid and complete working, detail and construction drawings in such a way that the contractor doing the work can understand and implement them without difficulty. The working planning must be so precise that no unintended scope for interpretation or dimensioning is allowed. But it does not have to define every screw in detail, as it can be assumed that the construction specialist will have the necessary expert knowledge. Possible requirements laid down by the planning authorities are also built into the working plans. Working planning must be continued and adapted during the building phase, if changes or confusions arise.

Representing
intersected
structural
elements

As a rule, the intersected structural elements are presented on a scale of 1:50 so that they can contain direct structural statements about the wall structure (e.g. masonry rendered on both sides or reinforced concrete ceiling with floating screed). Openings and slits in walls and ceilings must also be shown. These are often needed for service installations (e.g. fireplace, ducts for heating, sanitary, ventilation and electrical services) and should be agreed with the planner responsible. Slits are shown by a diagonal line; as soon as the structural element is cut through completely, the opening is crossed through. Triangles can be solid black for emphasis.

Axes in
working plans

For buildings with repeating loadbearing systems, such as industrial or office buildings, the longitudinal and lateral axes of the loadbearing frame should be identified by numbers or letters. Thus, individual areas can be categorized directly in such a way that the structural engineer can relate to the system and work with the axis definitions. Axes are drawn with dash-dot lines, either throughout the drawing or outside the building only.

Dimensioning
working plans

All the dimensions needed for correct execution of the plans must be included at this stage. They include all the dimension chains already

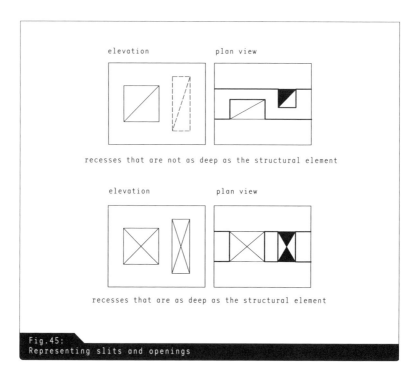

elevation plan view

recesses that are not as deep as the structural element

elevation plan view

recesses that are as deep as the structural element

Fig.45:
Representing slits and openings

shown in the design plans; but also the height, width and depth of every relevant structural element, without any omissions, and each element must be attached to a part of the building that can be used for on-site measuring. First, the general dimension chains are placed outside the building in the design plans; the detailed measurement chains are given inside the plan view or section.

Room labels
 The room labels contain much more information in the working plan than in the design plan. In addition to room numbers and room designations, we include:

_ the room area (A) in square metres
_ information about the surrounding walls (S), for example measurements of skirting boards
_ clearance height (CH), which is needed in turn for wall developments, e.g. measuring up for painting

It is generally also possible to specify floor, wall and ceiling fittings. As they cannot usually be accommodated inside a room, the fittings can be

Fig.46:
Defining axes

named in the plan header › see chapter Plan presentation and allocated to the rooms by means of abbreviations (e.g. W1, W2 for wall fitting etc.).

Working drawings

Plan views should give the following information:

_ The nature, qualities and dimensions of structural elements
_ Material-related presentation of wall, ceiling and floor fittings
_ Representation of the sealing and insulation levels
_ Door and window apertures with direction of opening, aperture and sill heights
_ Stairs and ramps with walking line, details on number and relation of steps and oversteps where applicable
_ Structural element qualities such as fire protection and sound insulation

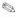

\\Tip:
When dimensioning, you should imagine yourself in the role of the construction specialist carrying out the work on the building site, who has to implement the plans on the spot. For example, if a door is to be set with its outer edge flush with the jamb, it makes little sense to dimension the centre axis of the door. Double dimensioning should also be avoided as far as possible, because it increases the amount of work needed to make a change made, and double dimension chains are easily overlooked, which can lead to inconsistencies within the plan.

_ Structural joints such as expansion joints or changes of covering

_ Wall and ceiling apertures, slits, shafts etc.

_ Technical fittings, channels, chimneys, drainage systems, under-drainage etc.

_ Fixed fitting and furnishings, sanitary and kitchen equipment

_ All dimensions of structural elements needed for the correct construction of the building (every protrusion or recess must have a dimension)

_ All the dimensions needed to establish room sizes and for quantity calculations

_ Room labels (see above)

_ Height related to ZL, so that the storey height can be assigned unambiguously

_ Detail references

Content of elevations and sections Elevations and sections will contain the following additional information:

_ Storey heights, clearance heights, shell heights

_ Height markers for shell and finished floor, foundations, roof edges etc.

_ Floor and roof structures

_ Presentation of the existing and planned organization of the terrain surface

_ Windows and doors with graphic representation of divisions and modes of opening

_ Gutters, downpipes, chimneys, roof structures

_ Covered intermediate floors, loadbearing walls and foundations as dashed lines

_ Course of foundation pit drawn in

_ Structural ceiling, roof and floor details

_ Glass specifications in elevations, if different

Façade section

It can make sense to draw a façade section in order to show the entire façade in detail and not take out individual points of detail. This will show the complete height development in section, interior view, exterior view and where applicable complemented with a plan view detail with all connection points and height relations between interior and façade.

Fig.47:
Details from working plans, scale 1:50

57

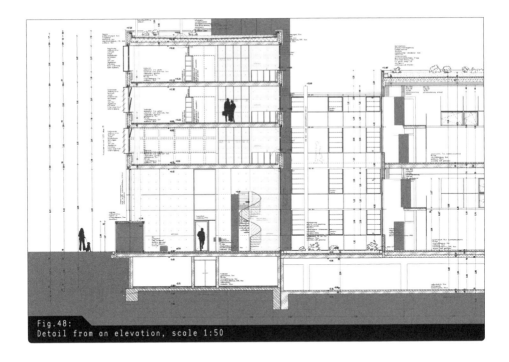

Installation plans for service areas

Installation plans are construction drawings that show the way partic-
ular structural elements are to be fitted. They may include fitting informa-
tion for the following structural elements:

_ Prefabricated reinforced concrete parts
_ Steel parts
_ Wooden beams or roof trusses
_ Areas of screed (showing expansion joints and conduits)
_ Laying stones (with layout grid, intersections and expansion joints)
_ Tiled surfaces (with layout grid, fittings and expansion joints)
_ Suspended ceilings (layout grids, fittings, acoustically effective
 areas etc.)
_ Double or cavity floors (layout grid, fittings under the floor)
_ Floor covering (layout grid or axes, change of floor covering etc.)

Installation plans are often drawn up on the basis of existing work-
ing plans, with the appropriate additional information entered, e.g.
through grid lines, colours or hatching. Installation plans cover a specific

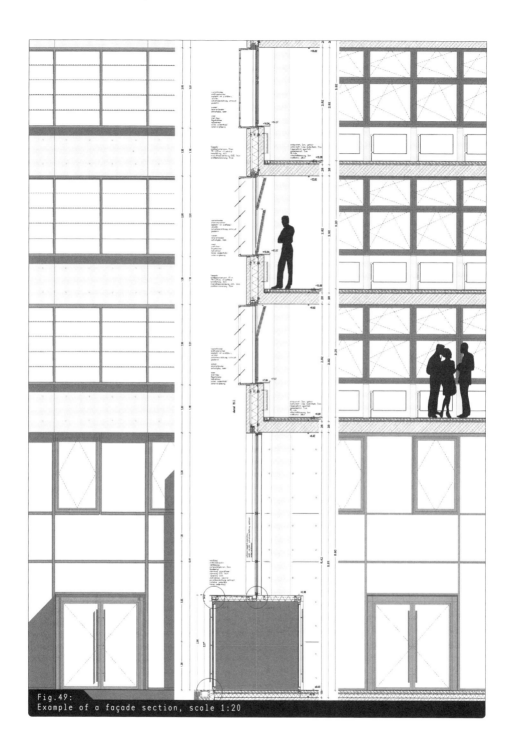

Fig.49:
Example of a façade section, scale 1:20

59

service area and are usually drawn up before tenders are invited for the particular field, so that the plans can be enclosed with the tender information.

Detailed plans

Detailed plans include all sorts of connections, system structures and transitions. As well as fixing control equipment in the drawing, there are particularly important points at which various control systems coincide or merge with each other. It is impossible to make a general statement about the detailed plans needed for a project, as they depend strongly on the individual project, the depth of detail required, the planning demands, and questions and uncertainties within the firms doing the work. Typical areas where detail is needed are:

_ Façade: window joints and systems, transition between ground and rising walls, connections between façade and roof, corner situations, external doors, balconies, sills and parapets, shades against sun and glare
_ Footings: foundations, drainage, sealing, insulation at ground level
_ Roof: attic, eaves, ridge, verge, gable, roof apertures such as chimneys, ventilators, skylights and roof windows
_ Stairs: system section, upper and lower connection, landings, banisters, handrails
_ Floor and ceiling fittings: system sketches for all ceiling fittings used, transitions between different floor types, connections to rising building sections, fixtures, conduits
_ Doors: system doors, frame systems, steel-framed doors, lift doors, shaft caps
_ Dry construction: connections of walls to façade, shell structure, floor and ceiling, suspended ceilings
_ WCs, kitchens, fitted furniture: structural details, connections, WC dividing walls etc.

Site installation plans

Site installation and organization plans coordinate the site and the construction firms involved. It is often unnecessary to draw up a separate site installation plan for small projects. But if there is only a small amount of room on site, it makes sense to do so, to avoid getting in each other's way and using the plot inefficiently. Hence, the following should be recorded in a site installation plan:

_ Storage areas and working areas/site road
_ Site management containers

_ Accommodation and sanitary facilities
_ Working areas around the building
_ Excavation pit
_ Lifting equipment (e.g. cranes) with radius and operational area
_ Building fences, entrances, signs etc.
_ Areas for individual trades (e.g. bending and cutting areas for concrete construction)
_ Soil storage areas where applicable
_ Power and water supplies, disposal facilities, rubbish management etc.

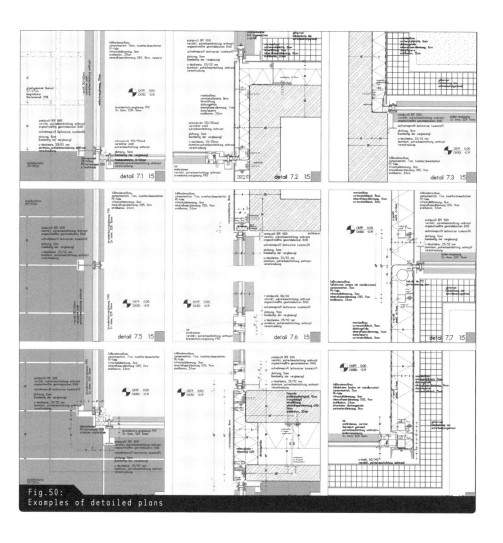

Fig.50:
Examples of detailed plans

Workshop drawings by firms involved in the project

Construction firms in different service areas involved in the project make their own workshop drawings on the basis of the working plans (sometimes also called works drawings). These are submitted to the planners before building starts and must be examined and signed off by them. Typical specialist firms who make their own workshop drawings include the following service fields:

_ Metal or steel construction work (windows, steel constructions, railings etc.)
_ Timber or carpentry work (wooden structures, roof trusses, windows etc.)
_ Ventilation construction work
_ Lift construction work

SPECIALIST PLANNING

Loadbearing structures

Working plans for structural engineers

Structural engineers draw their own working plans, placing particular emphasis on statically relevant elements. Which plans are drawn depends primarily on the choice of building materials. If the building is to be in reinforced concrete, encasement and reinforcement plans should be prepared; for wood or steel construction, plans for the appropriate rafters, timber and steel construction.

Position plan

> > \mathcal{P}

Position plans show individual positions to clarify the statical calculations. The positions are numbered on the basis of the design drawings, and these numbers are also found in the statical calculation.

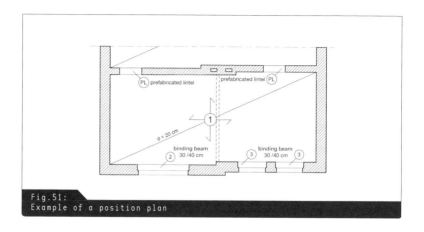

Fig.51:
Example of a position plan

\\ Hint:
Plan views for structural engineering planning do not usually present a top view of the floor below, but of the ceiling above it. A structural engineer's plan view for the 2nd floor shows, as well as the identically intersected structural elements, a different view from the architects' plans. For clarification you should imagine a mirror-floor showing all the outlines of the ceiling.

\\ Example:
A reinforced concrete beam is calculated statically and allotted the number 21. This beam is then also given the number 21 on the position plan, to make it clear to which beam in the building the statical calculation applies. If applicable, all the beams that are the same can be allotted the same number.

Encasement and reinforcement plan

Encasement and reinforcement plans are drawn up for reinforced concrete buildings. Here, shell plans show the structural elements to be encased (e.g. a reinforced concrete ceiling or wall). Encasement plans are particularly important if the subsequent surface is to be important visually (e.g. for fair-face concrete walls).

Encasement plans show the ceiling above the storey shown with:

_ axis, mass and height
_ supported or loadbearing construction elements
_ cavities relevant to loadbearing
_ types and strength classes
_ directions of span

Reinforcement plans contain information about reinforcement mats and bars to be built into a reinforced concrete section. A mat is usually shown as a rectangular area with a diagonal line marked with the mat type. Additional information for reinforcement plans:

_ Concrete steel types
_ Number, diameter, shape and length of steel bars and welds
_ Concrete strength classes, concrete covering
_ Apertures and special structures
_ Precise steel or item lists for construction to complement the drawing

Timber construction plan

> 🗋

Timber construction plans are drawn up for wooden structures, showing the precise position and dimensions of the individual timber construction elements (beams, supports, purlins etc.). As a rule, axes are dimensioned and connection points shown separately in detail. For example, if a pitched roof is to be built, the position and dimensions of the purlins and rafters must be shown in a rafter plan.

🗋
\\Hint:
Timber constructions and rafter plans are described in detail in: *Basics Roof Construction* by Tanja Brotrück, published by Birkhäuser Publishers, Basel 2007.

Building services

Special plan are also drawn up for building or domestic service installations, providing a basis for the installing the service equipment. Separate plans are usually made for each service. Particular services include:

_ heating installation
_ water supply and sewerage installations
_ ventilation installation
_ electrical installations
_ fire technology and alarms
_ data technology
_ lift technology

As well as the actual rooms for services, such as a utilities room, boiler room or similar, the pipe runs, holes and cable runs are the most important features. A plan showing slits and holes is often prepared to be included in the architects' plans, giving precise details of interventions in the shell.

PLAN PRESENTATION

If a drawing is to be issued in paper form, the paper format must be established to meet the demands of modern reproduction, and given a plan header.

PLAN COMPOSITION

Drawing area

Once the size of the building or section of a building to be shown and the scale of the drawing are fixed, the necessary amount of drawing space can be calculated. Then an appropriate area is added to the building dimensions on both sides to allow space for the dimension chains, and the drawing area needed is calculated on the basis of the scale. A plan header must be accommodated next to the drawing area (see below) and where applicable a frame, allowing for the intersecting edges.

Choice of paper format

All kinds of plan formats with different side measurements are possible for presentation purposes (competitions, student assignments). For example, a long, narrow building could be presented on paper with the same proportions, which would enhance the effect of the building's shape.

It generally makes sense to choose a common paper format for construction drawings (e.g. the DIN A series), as this can be reproduced easily. Large-format paper is needed for working plans, while for detailed drawings it is usually advantageous to use a format such as DIN-A3, which can be duplicated on most photocopiers. › see chapter Principles of representation

Different scales

Drawings can also appear on different scales on a single plan: for example, it can make sense to show appropriate details of individual anchor points alongside a façade section. Care should be taken so that the scale for the individual drawing can be identified precisely through clear labelling.

PLAN HEADER

Each plan contains a plan header, showing clearly which project and what details this particular plan shows. The header is usually placed in the bottom right-hand corner of the plan. Plan headers for presentation and construction drawings are organized differently.

Presentation plan header

If the plans are intended for presentation purposes, they should have a corresponding plan header. The overall graphic design of the plan usually includes the header. As well as the project name, it gives details of scale, plan contents, (e.g. ground floor) and author. Supporting design pictograms, explanatory sketches on the section, or plan view level and north arrows can also be included in plan headers.

For university and college projects, the student's matriculation number should be included, as well as his or her name, department or

66

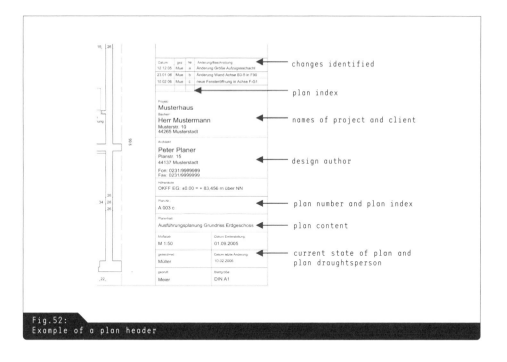

professor. For competitions, names or attributions do not usually feature on the plans. Instead, a camouflage number is often provided in the competition documents, and is placed in a particular corner of the plan. It is submitted with the competition plans in a sealed envelope, which will be opened only after the competition has been judged, to reveal the author of the design.

Construction drawing plan header

For construction drawings, the plan header first names the client, the author of the design, the plan draughtsperson and the scale. The current status of the plan is indicated. As new developments or specialist planning material have to be worked in regularly, the precise date of the current plan must be recorded. It is also a good idea to give the dates of the first version and the current revision. It is also helpful for understanding the additional data to include a summary of the plan changes to date. Building permission plans usually have plan numbers, which define them unambiguously. For simplicity, the current position expressed by the plan can be incorporated in the plan number: Plan A34d then means: working plan no. 34, fourth revision (d). Of course plan numbers can be allotted as wished; it is easier to administer the plans if a system is established at the beginning of the project and agreed with all concerned.

67

PLAN DISTRIBUTION

It is rare nowadays for plans to be drawn by hand, and CAD programs are generally used, making it easier to duplicate and distribute plans than when they are drawn by hand.

Plotting

CAD files are printed on plotters; smaller formats can be produced on standard commercial printers. Plotters are large-format printers, usually in the A1 or AO format, and plans are printed on them from paper rolls. The roll widths are generally 61.5 cm for A1 rolls and 91.5 cm for AO. The size of the plan can be input individually in most CAD programs, so that any plan format compatible with the width of the roll can be used.

Copying

If a plan that already exists on paper is to be copied, large-format copiers are available. These usually operate with the same roll widths as plotters. Colour copies of large-format plans are generally very expensive, so a plan should be reproduced by multiple plotting. It is worth choosing a plan format for detail drawings that can be duplicated on standard commercial copiers.

Blueprints

If hand drawings are produced on tracing paper, it is possible to make blueprints of them, rather than large-format copies. Here, blueprint paper is placed on top of the original tracing paper, and exposed to ultraviolet light in a blueprint machine. Blueprint papers exist in various colour shades, and can then be called black-, red- or blueprints.

Blueprints are rarely used today because they have been replaced by CAD drawings, but they offer a reasonably priced possibility for reproducing hand drawings.

\\Tip:
Copy-shops often have mechanical folding machines that make it easier to fold a lot of plans. If you have to fold the plans yourself, it is best to use a sheet of A4 paper and a set square. First, take the left-hand side of the plan and fold it upwards to the width of the A4 sheet. The fold can be smoothed down with the help of the set square. Then the right-hand side is folded to a width of about 19 cm, until the remainder can be folded in the middle if necessary. Now fold the remaining strip back to the height of the A4 sheet (several times for larger formats). The inner corner, as shown on the diagram, is then folded inwards, so that is not perforated at the subsequent hole-punching stage. If you use the plan header and plan frame frequently on a CAD plotter, it is possible to draw in little lines on the plan frame, so that there is no need to measure, and the plan can be folded directly along the lines.

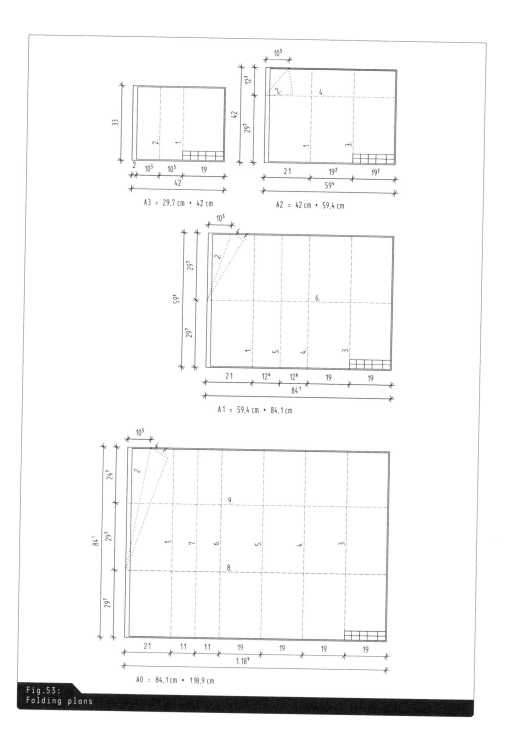

A3 = 29,7 cm • 42 cm

A2 = 42 cm • 59,4 cm

A1 = 59,4 cm • 84,1 cm

A0 = 84,1 cm • 118,9 cm

Fig.53:
Folding plans

69

Folding

In many cases, plans are circulated not in their original size, but in A4 format, which means that larger formats have to be folded to A4 size. It is important here to ensure that the plan header is visible in the bottom right-hand corner even when the plan is folded. It should also be possible to unfold the plan even when it is filed away, so holes should be punched in the lower left-hand area only.

APPENDIX

SYMBOLS

Table 4:
Symbols for sanitary fittings

Item	Symbol
Hand basin	
Basin	
WC with cistern	
WC without cistern	
Bidet	
Urinal	
Shower-base	
Bathtub	
Washing machine	
Tumble dryer	
Corner bathtub	

Table 5: Symbols for kitchen fittings	
Item	**Symbol**
Cupboard under	
Cupboard over	
Cupboard under and over	
Sink with draining board	
Gas cooker	
Electric cooker	
Cooker with oven	
Built-in oven	
Worktop	
Refrigerator	
Freezer	
Dishwasher	
Microwave oven	
Extractor hood	
Chair	
Table	

Table 6:
Symbols for furniture

Item	Symbol
Cupboard	
Armchair	
Sofa	
Table	
Chair	
Grand piano	
Upright piano	
Desk	
Wardrobe	
Single bed	
Single bed with bedside table	
Double bed	
Double bed with bedside table	

STANDARDS

Large areas of Technical Drawing are covered by international standards. For this reason, they are standardized by ISO standards, which are recognized in most countries. The following table gives the valid ISO standards, which have generally been adopted by the national standardization institutions (ISO 128 would then be called DIN ISO 128 in Germany, for example).

Table 7:
Relevant ISO standards

ISO standards	Description
ISO 128	Technical drawings. General principles of presentation
ISO 216	Writing paper and certain classes of printed matter. Trimmed sizes. A and B series
ISO 2594	Building drawings – Projection methods
ISO 3766	Construction drawings. Simplified representation of concrete reinforcement
ISO 4067	Building and civil engineering drawings – Installations
ISO 4069	Building and civil engineering drawings – Representation of areas on sections and views – General principles
ISO 4157	Construction drawings – Designation systems
ISO 5455	Technical drawings. Scales
ISO 5456	Technical drawings. Projection methods
ISO 6284	Construction drawings – Indication of limit deviations
ISO 7518	Construction drawings. Simplified representation of demolition and rebuilding
ISO 7519	Construction drawings. General principles of presentation for general arrangement and assembly drawings
ISO 8048	Technical drawings. Construction drawings. Representation of views, sections and cuts
ISO 8560	Construction drawings. Representation of modular sizes, lines and grids
ISO 9431	Construction drawings. Spaces for drawing and for text, and title blocks on drawing sheets
ISO 10209	Technical product documentation. Vocabulary. Terms relating to technical drawings
ISO 11091	Construction drawings. Landscape drawing practice

Series editor: Bert Bielefeld
Conception: Bert Bielefeld, Annette Gref

Layout and Cover design: Muriel Comby
Translation into English: Michael Robinson
English Copy editing: Monica Buckland

Figures 48–51 Maike Schrader, all other
illustrations by the authors.

A CIP catalogue record for this book is
available from the Library of Congress,
Washington D.C., USA

Bibliographic information published by
Die Deutsche Bibliothek
Die Deutsche Bibliothek lists this publication
in the Deutsche Nationalbibliografie; detailed
bibliographic data is available on the Internet
at http://dnb.ddb.de.

This book is also available in a German
(ISBN 3-7643-7642-2) and a French (ISBN 3-
7643-7951-0) language edition.

© 2007 Birkhäuser – Publishers for Architecture,
P.O. Box 133, CH-4010 Basel, Switzerland
Member of Springer Science + Business Media

Printed on acid-free paper produced from
chlorine-free pulp. TCF ∞
Printed in Germany

ISBN-10: 3-7643-7644-9
ISBN-13: 978-3-7643-7644-4

9 8 7 6 5 4 3 2 1 www.birkhauser.ch